CREATIONS ARE NUMBERLESS,
I VOW TO FREE THEM

MICHAEL VELLIQUETTE

CONTENTS

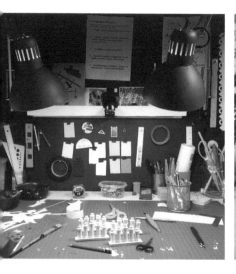
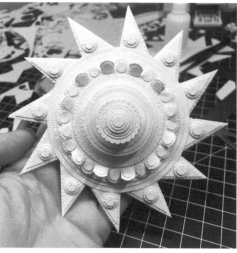
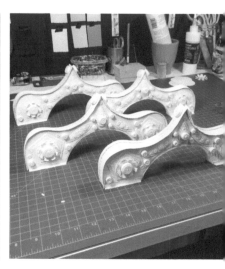

INTRODUCTION

KATE MOTHES

The self-aware mind is always attempting to place the self within a context, trying to understand our surroundings and how we fit within them. A shift in scale, use, or perspective induces our perception of our surrounding environment to adapt, along with our emotional response or relationship to object, space, and ourselves.

Michael Velliquette's choice to work with an everyday material like paper affords him the freedom to think fantastically on a small scale. Today we take paper for granted, but few developments in human history have had as great an impact on culture and learning as the invention of paper. It can be made incredibly strong and last for centuries, yet it can completely disintegrate when exposed to the elements. This inherent vulnerability lends itself perfectly to Velliquette's fortified yet delicate structures, which are solid yet airy, precise yet organic.

Each symmetrical structure highlights the materiality and ephemeral quality of a humble, lightweight material. They are at once abstract layers and shapes made from colored paper, and also structures that from one moment to the next suggest fortress-like constructions, tiered mandalas, or complex mechanical gears. Velliquette redefines the unassuming nature of paper by constructing objects that convey strength, intent, and durability, but which also require conscious observation and care.

The mathematical precision of the placement of each piece of paper is matched by exquisitely hand-cut edges, notches, and punctures. The work of the artist's hand is traceable throughout each piece: the process of construction is as systematic as it is mysterious, amplifying our curiosity about how it was engineered, just as one does when looking at the vaulted ceiling of a medieval cathedral or the exactness of a Tibetan Buddhist sand mandala. Curiosity and imagination are interconnected in human experience. Each sculpture encourages one to explore it and invokes a sense of adventure, like an elaborate labyrinth or ornate temple in which we note the scale or the interplay of form and light, but there are always new details to discover.

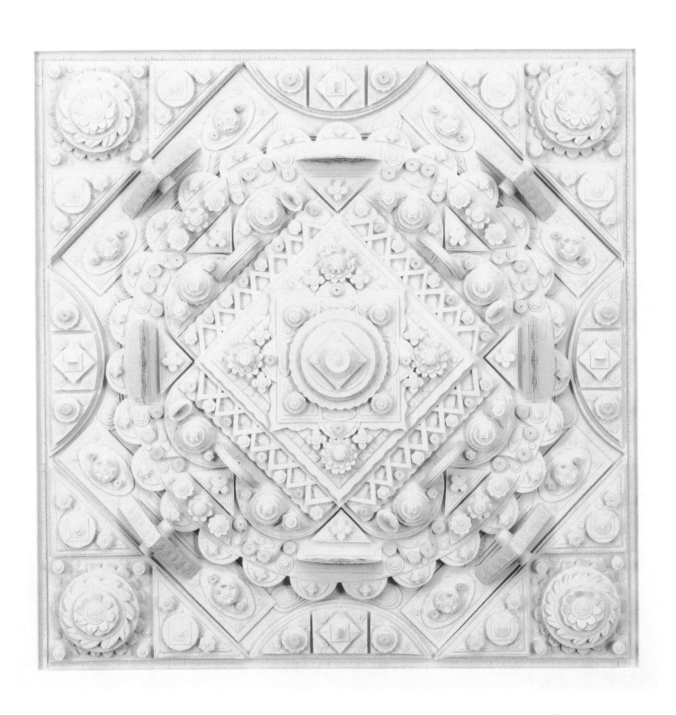

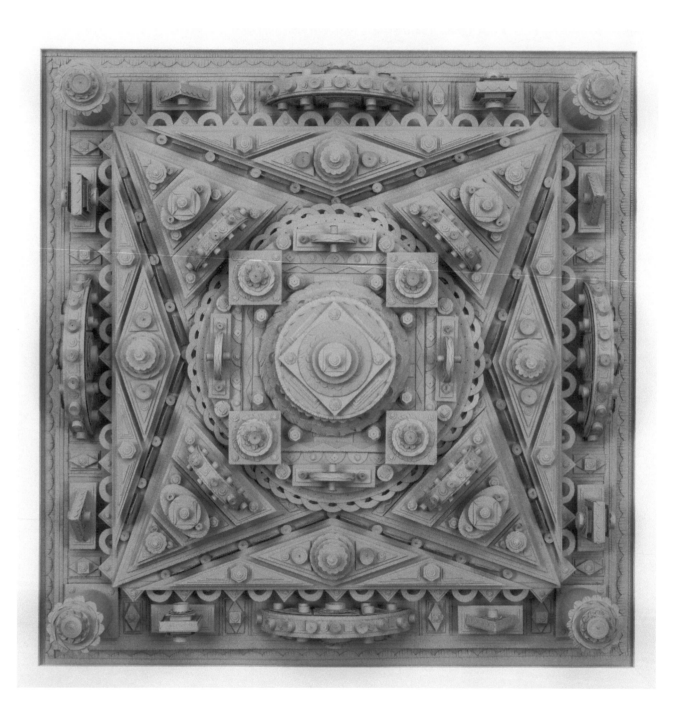

Then the Knowing Comes: I Can Open to Another Life That's Wide and Timeless, 25″ x 25″ x 5″

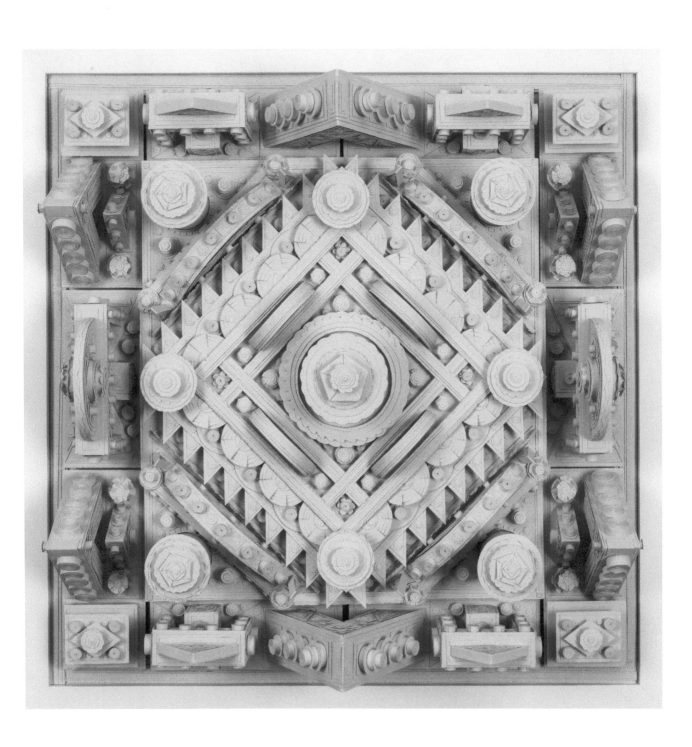

Then in One Vast Thousandfold Thought I Could Think You Up to Where Thinking Ends, 20" x 20" x 6" | **5**

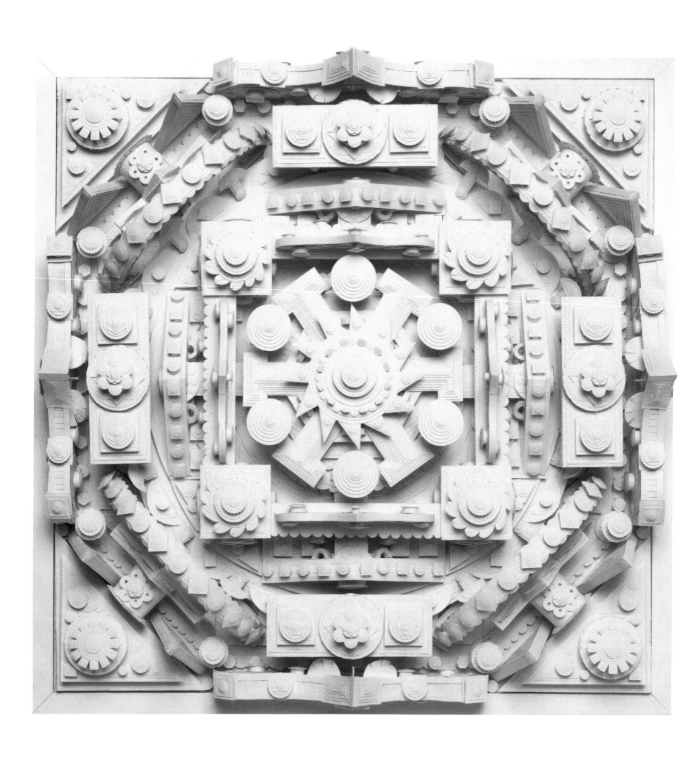

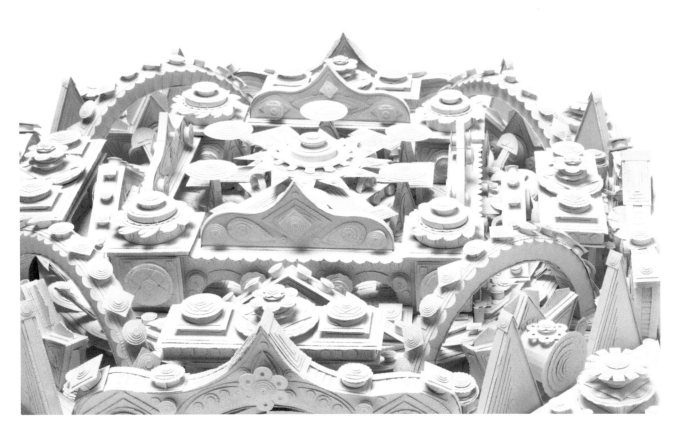
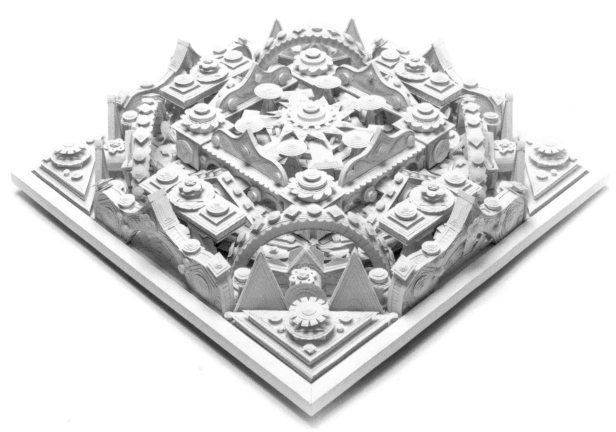

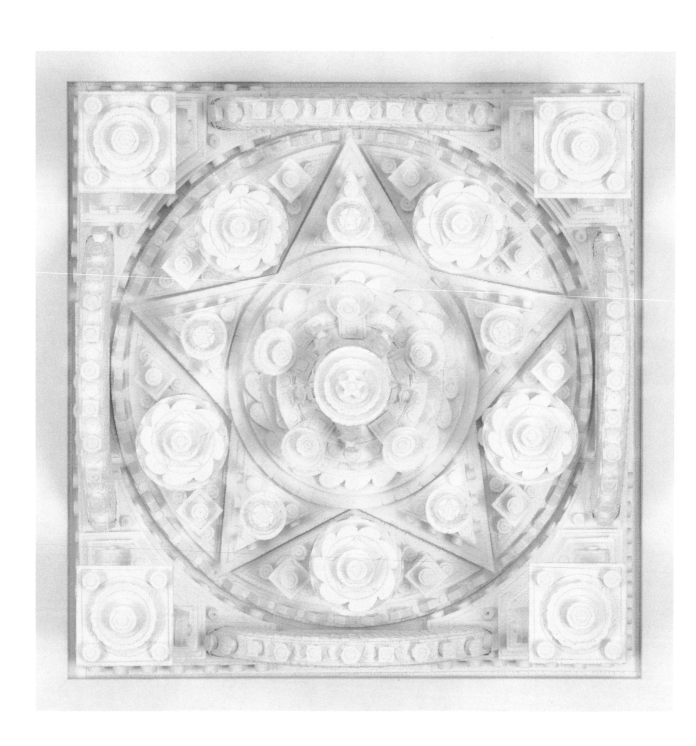

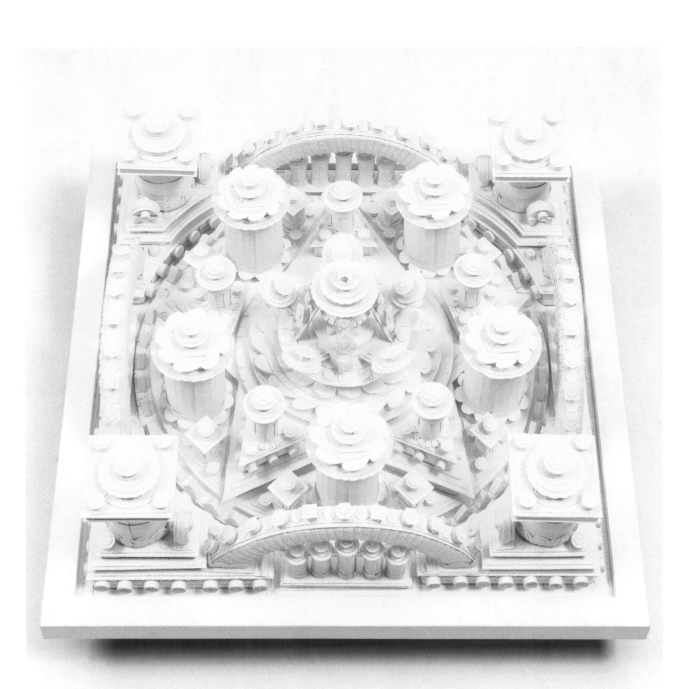

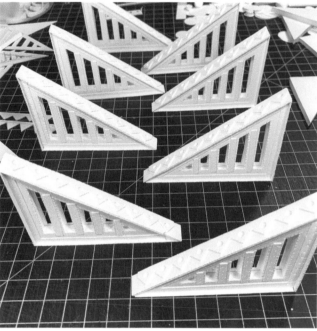

STRUCTURES OF SUFFERING // OBJECTS OF RAPTURE

ANTHONY LOVENHEIM IRWIN

Metaphor, simile, analysis. These stupid human tricks rob objects of their elaborate material integrities. In the quixotic quest for meaning, critics unravel art into linear logics of lifeless logos.

It is scary to take in a body of work without the protective armor of metaphor. To allow the thousand-cornered reality of matter to exist as its *raison d'etre*. The false division between name and form that orients so much casual experience of the world is blurred by the intricacies in Michael Velliquette's recent work. Texture triumphs over text when paper completes its chrysalis. Manuscripts only mediate illumination when fully flowered and laid bare. Here contour runs circles around folded uniformity. Deep

shadows shade caverns of monochrome where rolled and scored ornaments stand sentinel. Light tumbles through gauzy mazes before gently throwing itself back into the air.

Spend some time with the empty spaces that light creates. Let your mind occupy a point someplace suspended between these paper forms and spaces that surrounds them. Try to focus on only the edge of light as it caresses your favorite fold. Now look past the edge and blur your eyes. Don't forget to breathe.

These are made slowly.
Very slowly.
Be slowly with them.

Now show off how slow you are in front of them. Make them envy your mastery over slowness. Boast your slowness pridefully, you're in good company.

In their slowness these works do not point to anything. Instead, these fragile structures proudly proclaim: Thing itself is not empty. Ornament fills the void with its own material (anti)meaning.

These works disarm the weapons of the willfully obtuse.

Here is what happens when one allows themselves to be fully disarmed by them:

The beauty of Michael Velliquette's work embarrasses me. These exquisite pieces entice me to do the unspeakable. The almost impossibilities of their forms, the intricacies of their details, their repetitive textured perfections—each and all cause me dark fantasies. I want to scrunch them up to hear how they cry out in their final moments of integrity. I want to run the fingers of both my hands over them again and again to feel their furloughs and flaps and flips. I want the resulting little helicopter sounds to massage my ears. I want to pick off an expertly folded nub and pop it in my mouth and chew on it like a Mentos™. I want to turn two entire pieces inside-out and wear them over my two arms like detached sleeves as I walk through a hallway like a zombie, or through a forest like a bigfoot. I want to set them on fire in an open pit and watch their smoky tendrils escape into the sky. I want to breathe in their burnt essence and let it build up as tar in my lungs until I am suffocated by this perverse indulgence and gasp my last breath of bliss. I want to grill mushrooms on the glowing embers. I want to eat those mushrooms.

I am sorry, Michael. But this is your own fault.

When we spoke, I asked Michael if he ever thought about letting anyone touch the pieces. If he ever thought about not displaying them under their plastic vitrines. At the time I asked from a place of pushing the pieces into another realm of display—thinking it would be meaningful somehow if they slowly were damaged by the elements, by gallery goers, by inadvertent touch and the fluctuations in humidity and light.

I now can admit that I was lying to myself. I asked the question because I simply wanted to be able to touch them for myself, right there and then. I don't care if they change slowly—if they become a rumination on the gallery, or on time, or on the interactions between humans and materials. I only want to be able to engulf these pieces. To so fully and absolutely take in their every expression with my senses that it makes me long for another, undiscovered sense—something beyond touch, sight, hearing, taste, smell, and mind with which I could more fully consume them. I know that this would destroy them. They make it so that I simply don't care.

I also asked Michael what was inside of the pieces. It's less exciting than you would think. Foam, glue, a few pins.

I thought this was a deep question. It wasn't. Really, it was selfish and self-centered. I asked because what I really wanted to be inside of them was me. I now know that my deepest desire was for Michael to answer "what's inside of them? You!" And then he would wave his magic wand and I would be shrunken down and transported into one of the piece's interiors. I would be Tom-Thumbed into my own private *Lovey Town*. Oh, to be a prisoner in the most magnificent jail from which I never would escape! "This looks like Superman's fortress of solitude in here," I would think to myself, "only better!" And then I would realize that I could fly, just like Superman, but I would never fly out of my beloved jail. I would never again see my family, friends, and mentors whom I love, nor my enemies whom I hate, nor my professional colleagues and acquaintances whom I like just fine. I would just stay living in there because I would be so intoxicated by the intricacy and rolling shadows and nooks and crannies and monochromatic rapture. I wouldn't even think about anyone or anything else and eventually I would die, and my last words would be "thank you for this beautiful jail, Michael" and I would mean it sincerely and it wouldn't be at all sarcastic.

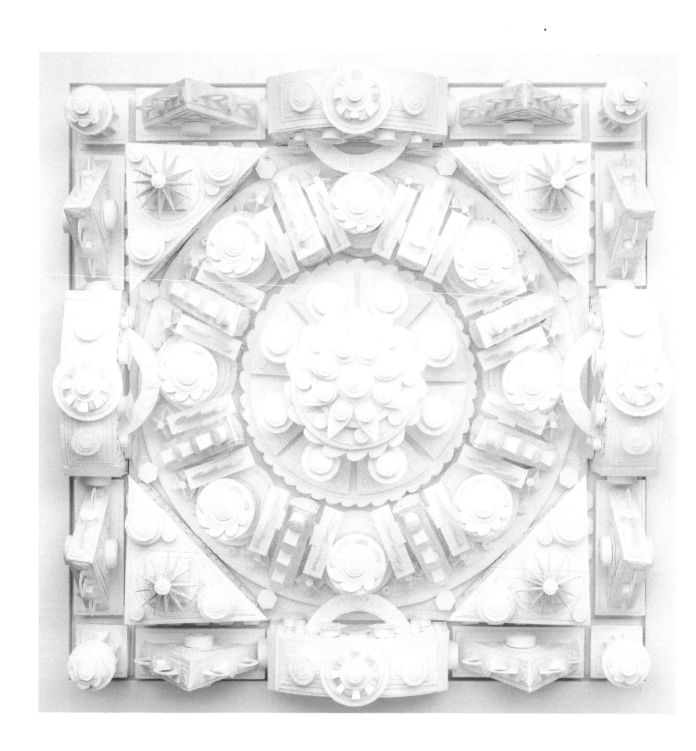

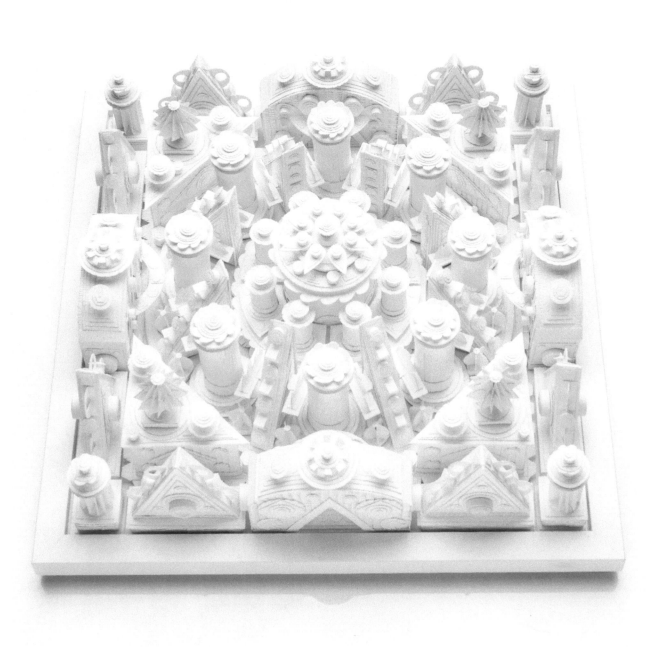

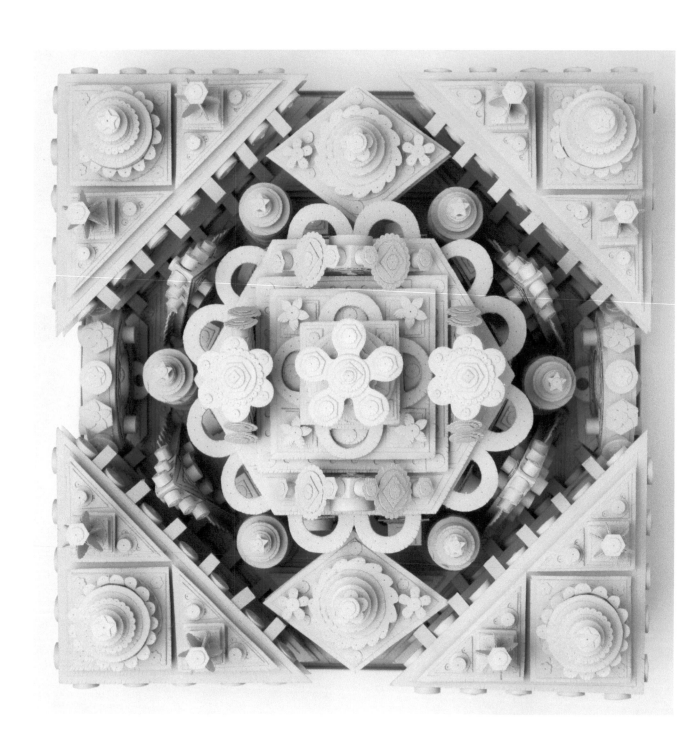

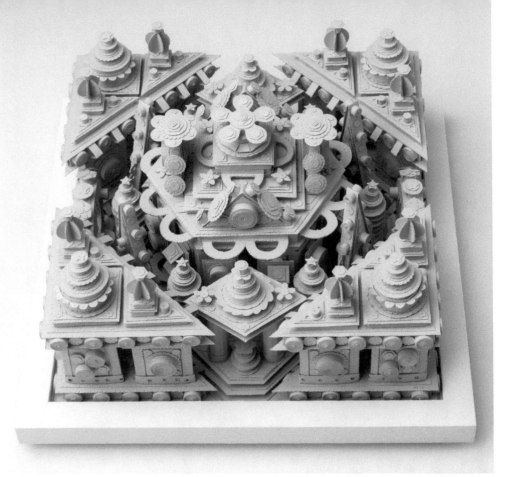
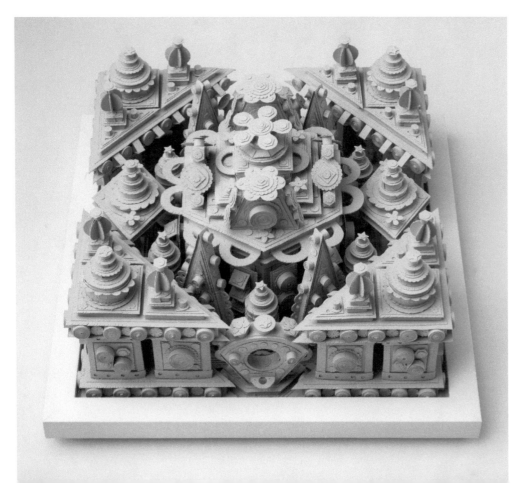

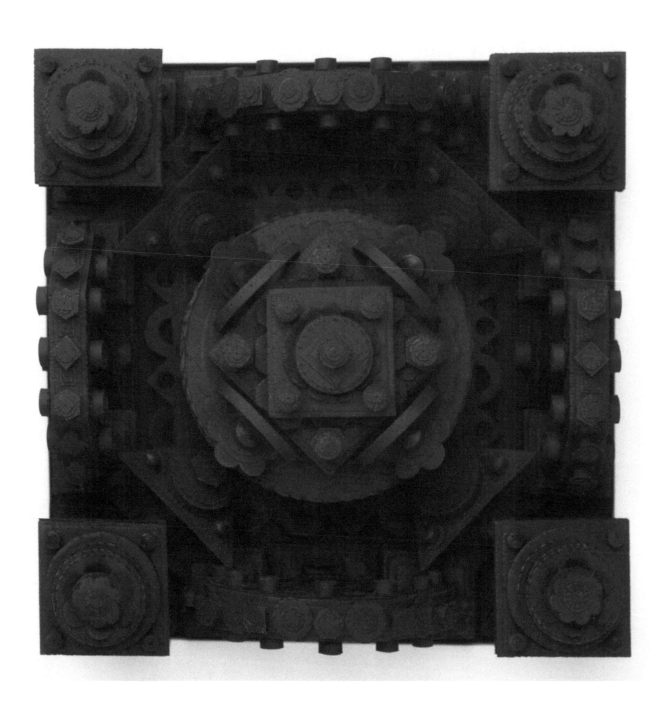

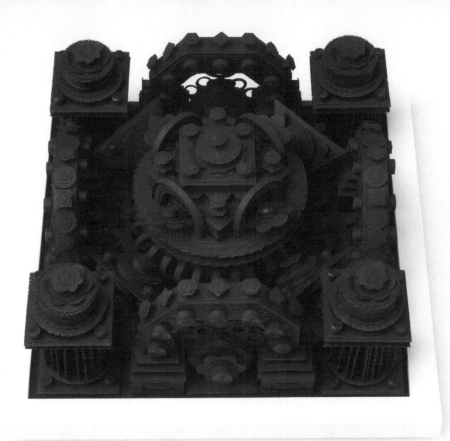

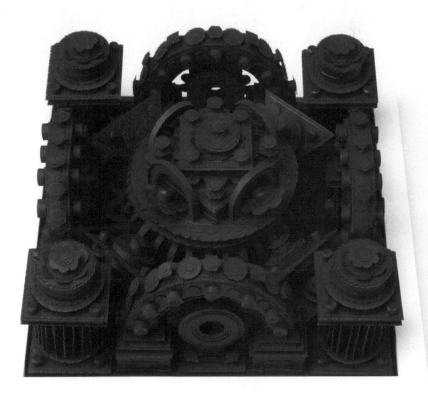

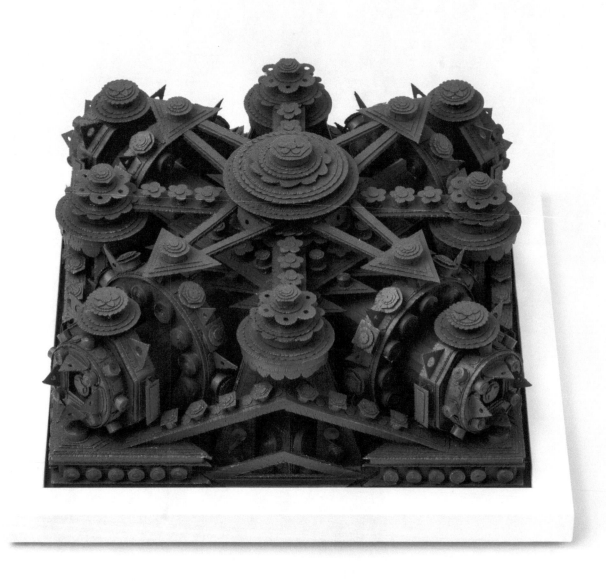

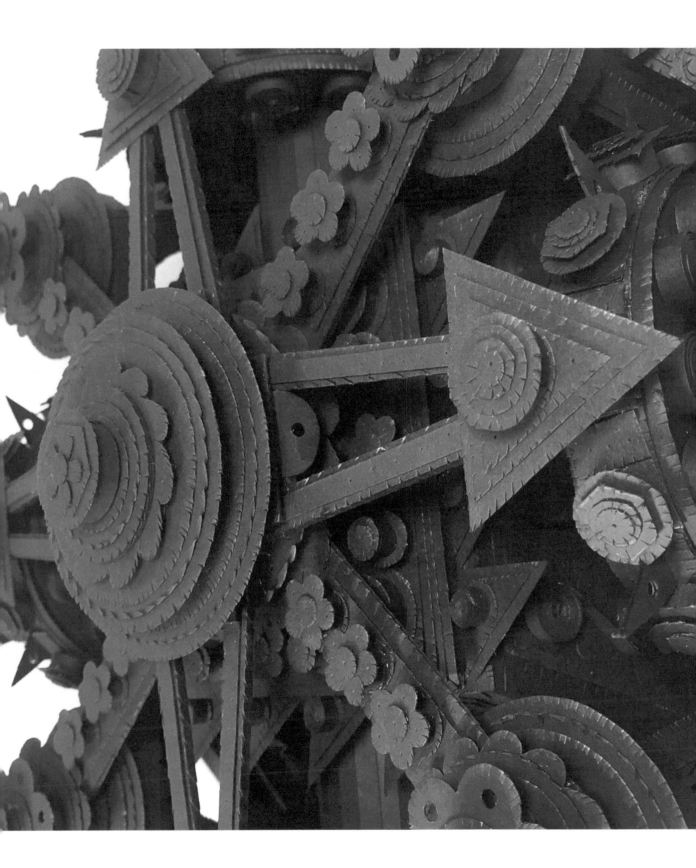

19

STAGE SETS FOR THE SOUL

WENDY WEIL ATWELL

The ornate, fantastical paper sculptures by Michael Velliquette are dream buildings come to life, pathways of the mind rendered into space. Monochromatic, and created on the scale of a maquette, his sculptures, with their stacked circular and square platforms, domes and other stupa-like constructions, reference sacred architecture, specifically ancient Buddhist temples such as Borobudur, a 9th century temple in Indonesia, built to embody the process of enlightenment. They range from 12 x 12" to 25 x 25" square and stand anywhere between 6" to 18" high. The artist's ingenuity as well as his time and labor are readily visible and so, despite their small scale, the sculptures possess a grandness or expansiveness that supersedes their sizes.

Working with only rough sketches, Velliquette finds a way to build his sculptures as he goes along, "like making a puzzle without directions." Leaving no flat surfaces and not one spot unembellished, even in the spaces invisible to the viewer, Velliquette spends anywhere from 300 to 500 hours to make each one. He cuts around 5000 pieces of paper

that he rolls, stacks and glues together, using a variety of techniques including book art; the ancient art of Chinese quilling; and the Japanese folding and cutting technique, Kirigami. Set inside plexi cases and exhibited at eye level—either on flat or lectern-like shelves, or vertically on the wall—the sculptures invite the viewer's eye to travel over and through their detailed spaces and to get lost inside their labyrinthine paths.

Velliquette culls his titles from varied sources including mystical poets and meditation teachers. Using found phrases such as (Untitled 4) Now heaven's river drowns its banks, and floods of joy have run abroad; (Untitled 5) Watch the stars and see yourself running with them; and (Untitled 7) When awareness encounters eternity it creates time, he points towards the ineffable. The sculptures' purely decorative, non-narrative style recalls the geometric splendor of the Alhambra, and suggests aniconism, rules in religious traditions, such as Judaism and Islamism, in which artistic representation of God and other divine beings must remain non-representational because they believe the

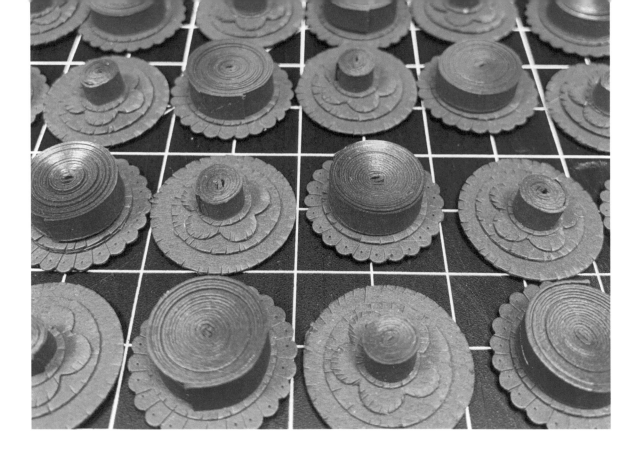

essence of God is awe-inspiring and infinite.

The Buddhist temple references endow Velliquette's sculptures with architectural qualities that affect the viewer's spatial relationship to them. It is less the body than the mind, or perhaps even the spirit, that gets pulled inside their worlds. Their presence feels vague and transcendent, despite the very real, very labor intensive artistic work of their composition.

This may be due to their restrained color palettes. Each of Velliquette's sculptures is only made from one paper and one color, ranging from white, grey, pale blue, to colors with Buddhist references like gold, dark red and royal blue. The use of only one color underscores the details of the cut paper work and highlights the formal composition. The forms' anonymity transcends the particular and this blankness exists in opposition the exuberant cut paper details, creating a static nature that holds the time the artist put into them like a well or a reflecting pool, a plentiful resource to dip into.

The sculptures' contemplative qualities transcend time's linear barriers. Even before the global pandemic, Velliquette began to use his studio and his art as a refuge from the 2016 election's toxic political climate, with its reversals on personal freedoms and hate campaigns. "I see these structures embodying the equanimity I felt was missing from my pre-meditation life, and definitely in the current political landscape. And I also hope it's a refuge for viewers, to be able to get close and imagine themselves in these spaces and similarly feel calm and grounded," said Velliquette. Each of the many round forms that he incorporates into his sculptures implies movement, but this is motion on a larger scale. There is the inevitable connotation of the dharma wheel: time spinning, the cycle of life, what Margaret Atwood refers to when she says, "The wheel of fortune rotates, fickle as the moon. Soon those who were down will move upward. And vice versa, of course."

It's easy to get lost in these paper sculpture's details, zooming in, but zooming out, these works touch on the mythical. They echo storied buildings from the past or the

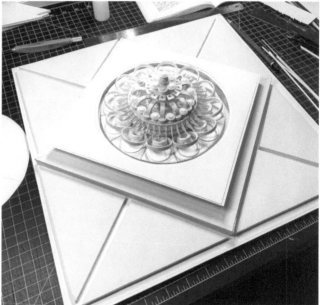

imaginary sites of fairy tales and fables: the labyrinth of Greek mythology; the Invisible Cities by Italo Calvino; and the Library of Babel by Jorge Luis Borges. Like Daedalus, Velliquette creates a trap, not for the Minotaur but time itself. In meditative practice, the labyrinth serves as a place to get lost inside, only to realize there is nowhere to go; you have already arrived at the place you are seeking. It brings an epiphany that suggests it is just on the other side of knowing, like a Zen slap of awakening, a thunderclap, tripping in a dream or a koan.

Velliquette maintains a mindfulness meditation practice and his works are manifested out of this process. Using his intuition and concentration, he builds up the forms that often involve repetitive tasks such as cutting the same shape 1000 times. This state of waking meditation creates a sense of distance and allows him to observe how his mind works.

The more I have been able over the years to recognize when my mind is just caught up in itself and see what is happening the sooner I'm able to get back to a sense [of] equanimity, balance, ease….Making the paper sculptures are a way [to] induce a similar mind state in my studio work, meaning a pleasant mind, that feels balanced and calm. I think the sense of order, balance, [and] repetition in the

sculptures just mirror that mind state. And lately, if I want to think more broadly about it, I think they might represent a sort of non-dual state of being, or gesture towards the state of 'awareness being aware of awareness.'

Built from a combination of intuition, concentration and skill, Velliquette's sculptures contain a nearly infinite amount of creative riffs. He works in that hazy, distant, nearly unobtainable zone that offers access to the transcendent. "When I'm making art and really into it, I disappear into the work. It's not me and the work, it's just this state of 'knowing/being the work.' I often say that I keep making art because it's the only time feel like I am truly who I am, meaning my sense of self slips away"—which makes his sculptures mandalas in their own right. They are monuments to his will and focus; the internal process that rendered them possible makes them beautiful space holders for a streamlined mental energy, extending from the open horizons of a clear mind. The wheel is always turning, time is always passing, and objects of contemplation offer the chance for stillness and clarity within this flow, to hold us in this suspension. Hence the sense that they exist out of time, crystalline. This space feels like a distant memory, a mirage-like city on a distant hill; it is a memory, we realize, not of a place but a state of being.

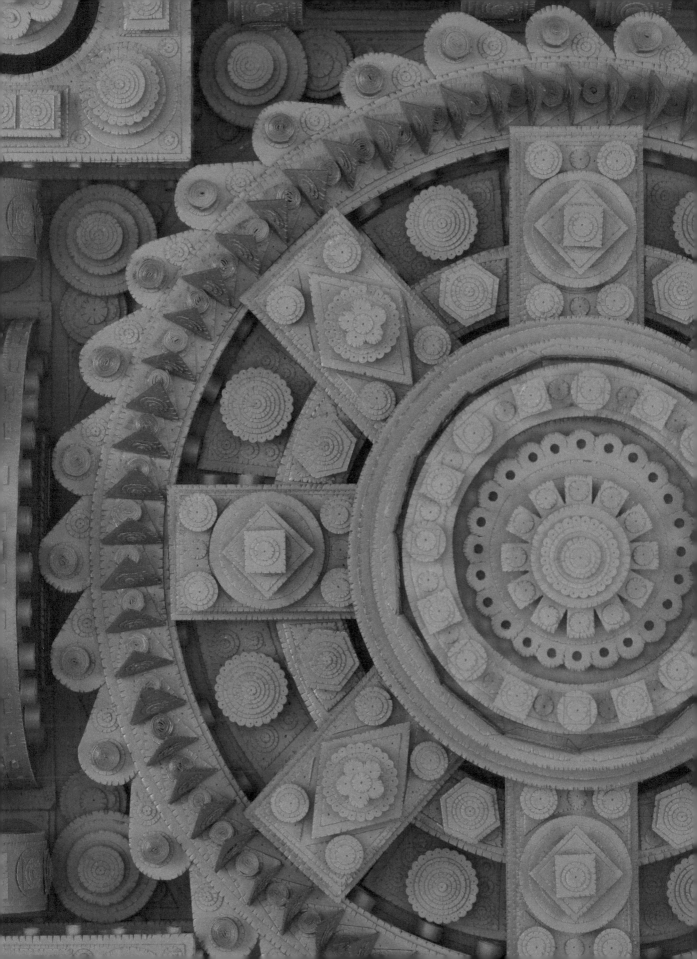

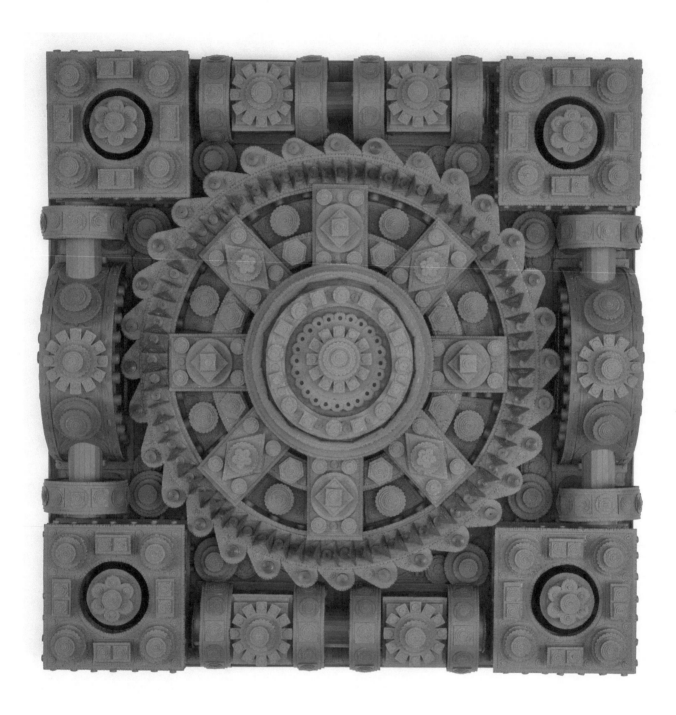

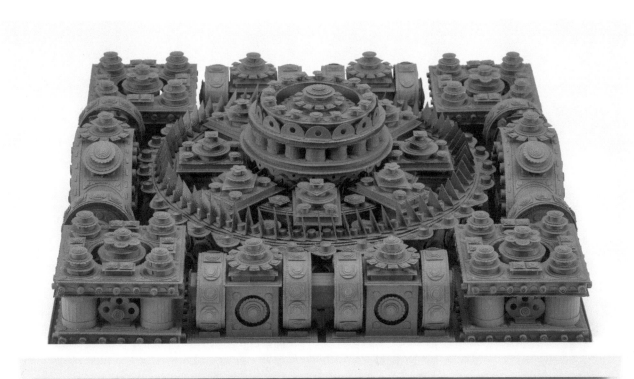

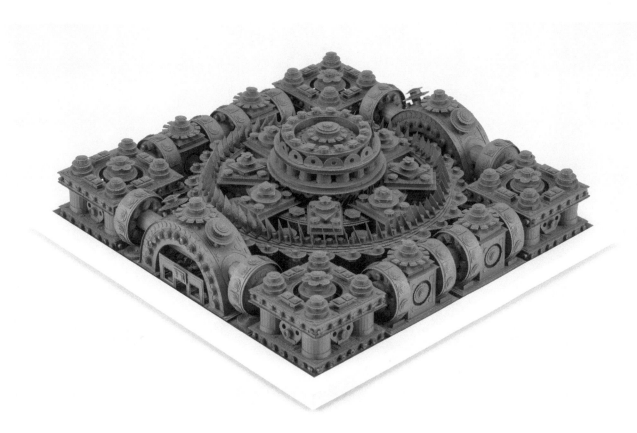

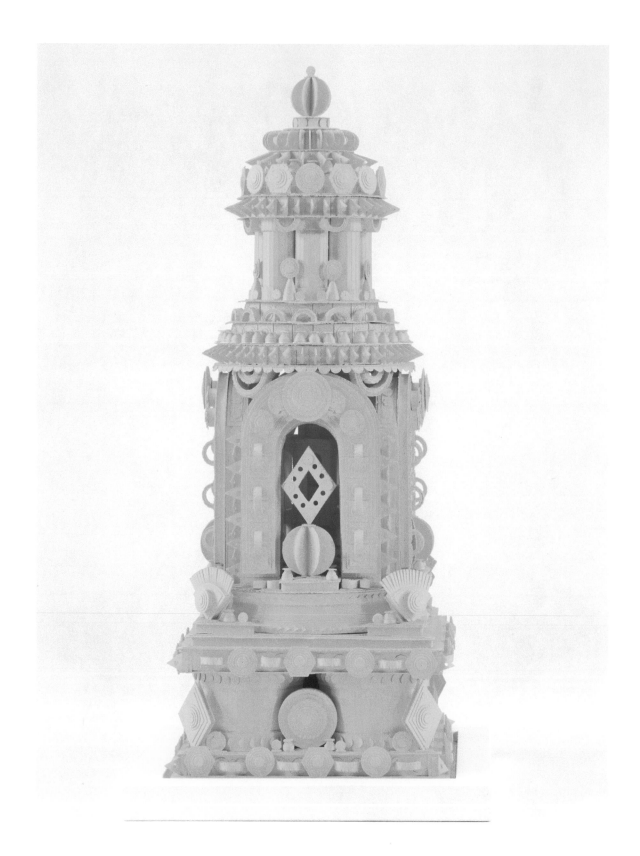

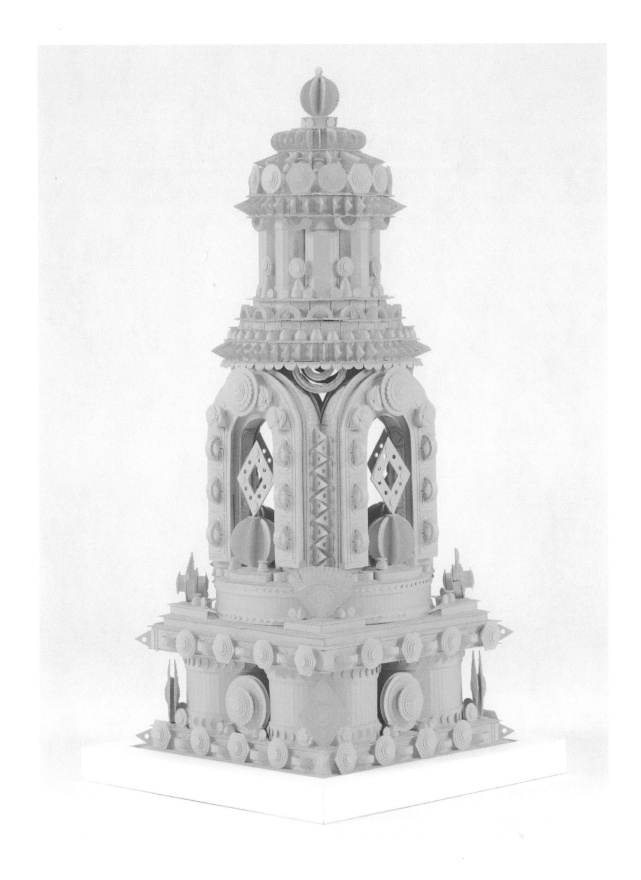

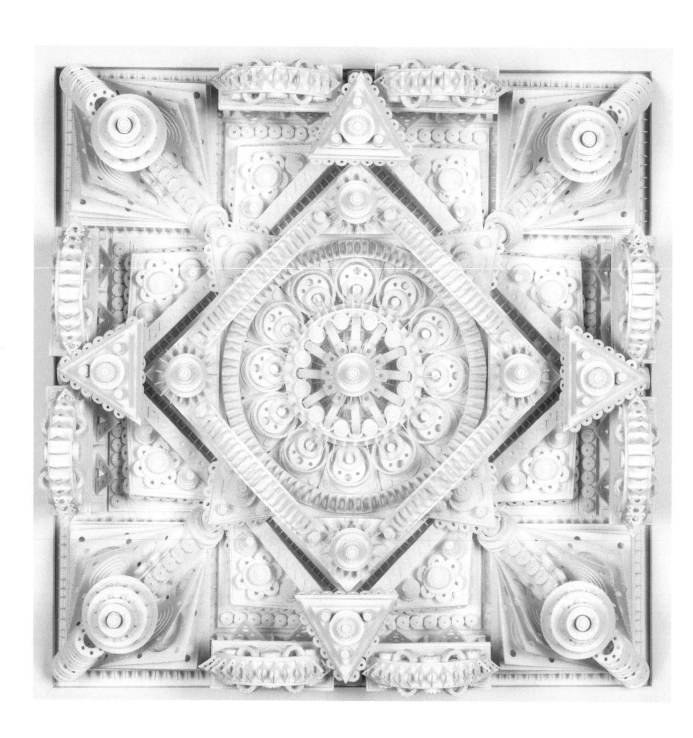

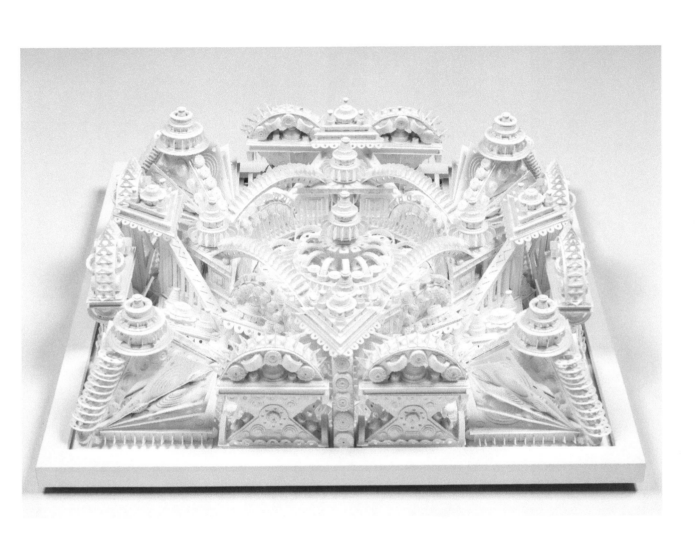

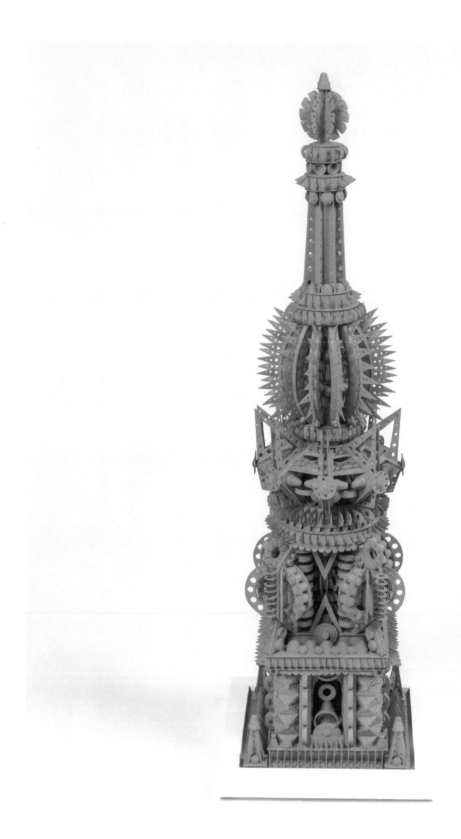

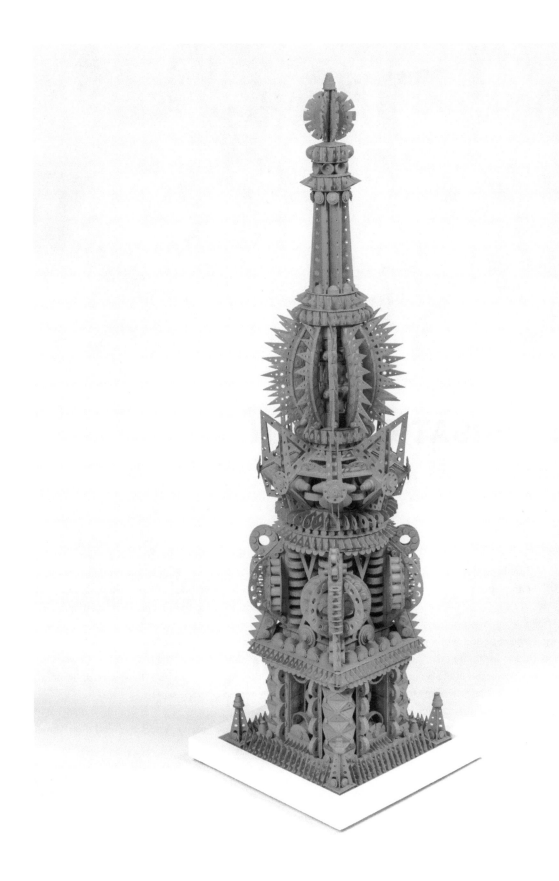

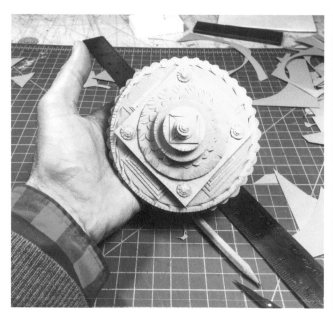 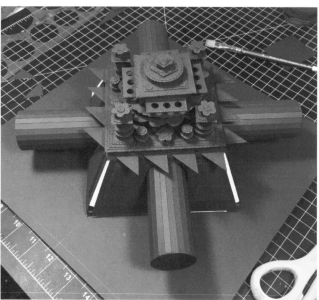

IN CONVERSATION WITH

THE PAPER ARTIST COLLECTIVE, 2019

PAC How long have you been working with paper?

Michael Velliquette: I began my investigations into paper art about 20 years ago somewhat accidentally, as I was using paper models as studies for larger installation work. Over time, I became more interested in the ability of this single, simple material to encapsulate all of my formal and conceptual interests by itself. Paper comes in endless textures, colors, and weights. It can be used in multiple dimensions. It's easy to handle and to manipulate, and it's available virtually anywhere. It's inherently ephemeral, but given the right conditions, it can last for centuries.

PAC: What attracts you to working with paper?

MV: As a material it has been used in human culture for at least two thousand years, and there is something that resonates for me about working with a medium that has such a longstanding presence in our lives. And, since it's been around for so long humans have been able to explore— and exploit— an astounding range of paper forms and functions. It's unparalleled in terms of its flexibility as a medium. I also think paper has so many beautiful contradictions. It can be durable or ephemeral, rigid or soft, sacred or disposable.

PAC: How have your paper works evolved over time?

MV: My early paper pieces were image-based. Throughout a period spanning ten years and over two hundred works, I investigated paper-crafting traditions from around the world and integrated them with my own wholly unique techniques. Over time, my work has become less tied to pictorial schemas and less concerned with representation

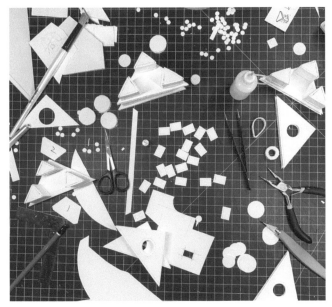
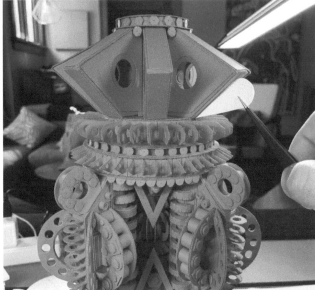

than with process.

My current approach has become more improvisational: instead of relying on drawn studies, I simply allow works to accrue. This handcrafting process is slow — depending on scale, finished works can take up to five hundred hours to manifest. This results in the production of fewer individual works, but each piece invites a greater wealth of interpretations. They can be displayed both horizontally as sculpture in the round or vertically as bas-reliefs. I encourage their investigation from multiple perspectives, both visual and conceptual.

PAC: Where do you find inspiration?

MV: I see parallels between my approach to art-making with religious, conceptual, and process-based art practices where expansive patterning and ornamentation, and where visual complexity and abundance are meant to allude to the infinite mystery of who we are.

PAC: What are your favorite papers to work with?

MV: For my sculptural series I prefer mid to heavier weight papers and card stocks in the 250-300gsm range. I like

papers that cut, score, fold, bend and roll easily while still maintaining their structural integrity.

I've used the Stonehenge Legion series and am currently working with Daler-Rowney's Canford line of card stock. These are commercially made, so they are quite smooth and uniform in terms of surface texture and color. In fact, those physical qualities of uniformity and evenness have underpinned some of the conceptual aims of this work in relation to my interest in making objects that manifest states of equanimity and balance in the experience of the viewer.

PAC: What tools could you not live without?

MV: Kai Scissors are my absolute hands down favorite brand. I have two coveted pairs from their 5000 series that I use daily—their 4" 5100 and 8" 5210. I have instructions to be buried with these.

Other necessities include a self-healing cutting mat, an Exacto knife with #11 blades, white PVA glue and a pin-head glue bottle, a quilling roller, a pair of tweezers, a bone folder, a 4" L-square, a 12" ruler, and some drafting templates for basic geometric shapes.

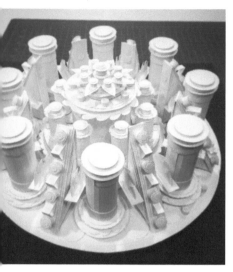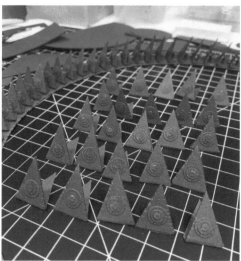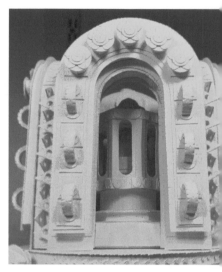

LIZ MILLER ARTIST BLOG, 2019

LM **Your paper sculptures are ornate and involve elaborate ornamentation—not unlike the many layers of ornament one sees in great cathedrals, the seemingly infinite patterning in Moorish architecture, or—and I think this is a more direct influence—mandalas. Your work is influenced by spirituality/religion, and you have studied Theravada Buddhism as well as the Vedic philosophy of Advaita or Non Dualism. Can you elaborate on the relationship between the forms and/ or process of making your work and the spiritual or religious connection? Does the slow process of making these works by hand relate on some level to spiritual practices?**

MV: About five years ago I started studying with a Theravada Buddhist teacher and practicing Vipassana meditation. In the first few months of my sitting practice I began to become more aware of ways I operated in the world that weren't serving my baseline happiness. Some aspects of this related to my studio practice. I started to see that as a working artist I often attached greater importance to what my work could help me attain in terms of bolstering

my ego. Getting some distance from that state of mind helped me to revivify a nurturing attitude towards my work—what I could do to support it, rather than focusing on what it could do to support me.

It was out of that space that the new paper sculptures manifested. They relate to the meditation practice in the sense that making these requires I work more slowly and intentionally than I had previously. I can't "tune out". Since they evolve from one cut shape to the next and I don't work from sketches I have to be more consciously present while making them. Another corollary has to do with the notion of skill. Buddhists use the word "skillful" to describe habits and actions that support more kind, compassionate and equanimous states of being. In terms of material handling and tool dexterity these are the most highly crafted works I have ever made and reflect an effort on my part to generate similar states through abstraction.

And yes, there are established precedents for the merging of spirit and form, in fact I believe it's one of our earliest means of creative expression as a species. So, all of the references you cited are in my spheres of influence. In this

34

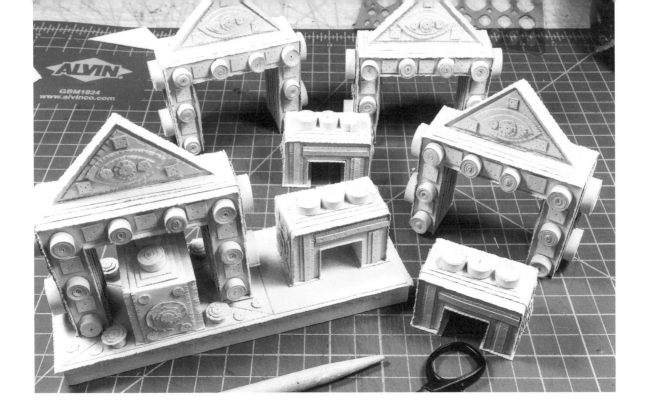

body of work, I've also embraced the Modernist axiom about "truth to materials". Paper has been integral to my practice for almost twenty years and this work marks a renewal in my commitment to the medium.

LM: The statement on your website describes the evolution of your work over the past fifteen years. One part that resonated with me is the portion where you discuss a transition from image-based works to works that are more ambiguous or multi-faceted in their references. I am currently going through a similar transition—it is simultaneously liberating and frightening. While I feel like the work is more conceptually layered and richer than ever, sometimes viewers struggle without being able to easily pinpoint a reference. What has this transition been like for you?

MV: For me the transition towards more non-objective work occurred with a shift in my process. When I start one of the new pieces, I don't plan them. I start by cutting out basic shapes and arranging them in concentric layers. I see what I've made in a single session and then determine if I want to continue or scrap it and start over. In subsequent sessions

I make more components that respond to what I've made previously. Individual forms accrue this way until they feel like a sufficiently finished piece to me, which can take anywhere from six weeks to six months. It's a more repetitive way of working for me but it never feels monotonous. There is a lot of slow-motion improvisation and I invent new techniques all the time. Despite how long they take to make I can never anticipate how they will ultimately look. It's always a surprise seeing what they look like when they're finished.

LM: Your work has ranged greatly in scale, ranging from giant site-specific installations to your more recent endeavors, which are still dazzling in craft and complexity, but are of a miniature scale in comparison to some of your earlier works. Talk about this scale shift, and how you see the relationship between these bodies of work.

MV: I've always been sensitive to the relationship of scale, form and space. When I think about it, going back to my childhood I took a keen interest in decorated environments. I made what I consider my first successful art installations in the early nineties while I was an undergrad at Florida State.

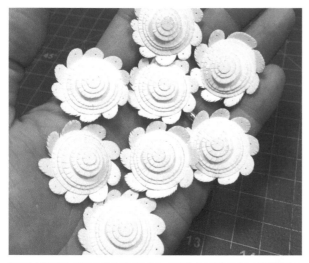

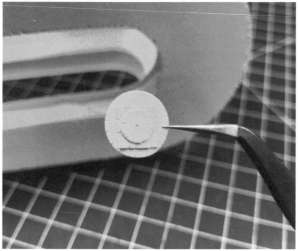

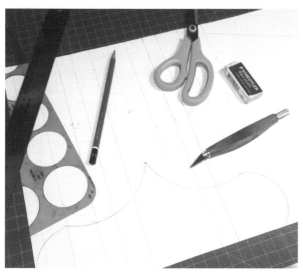

In terms of my studio production over the years I've moved somewhat seamlessly from large scale immersive spaces to more intimately sized works without giving it much thought. As my career developed and I started doing more and more shows I found myself thinking less skillfully about how scale served the work and instead focused more on the amount of work I thought necessary to fill a show.

That's changed with the paper sculptures. I began them during a period when I didn't have anything coming up show-wise. I remember feeling unmoored in the studio. But little by little a sense of spaciousness set in. Over subsequent months I made work without anyone looking and without any intention to ever show it. I was deliberate. I questioned every element. This allowed me to think about scale again as something generated from within the work's own instincts. So, right now it's true that I happen to be making things that are relatively small, but I know when I start to make larger work again it will be informed by this new skillset.

LM: While your new work is as intricate as ever, the color palette is a huge shift—your previous works were an explosion of bold color, and the newer works are quite muted and nearly monochrome. There is a unifying element to the limited palette, and also an almost somber effect. What was the catalyst for this transition? What are the conceptual implications of the pared down palette?

MV: A few years back I took a break from the colorful paper-based work while I had some larger site-specific projects going on. When I came back to the paper work, I found that my color sensibility had gone dormant. The color studies I made felt…forced. As the work became more sculptural, I realized that too much color was visually burdensome to them. The sculptures are more form-focused and the muted, monochrome palette is more supportive of the kind of contemplative experience I want people to have with them.

LM: When you aren't making art, where can we find you?

MV: These days I'm spending lots of time in the yoga studio practicing handstand!

CONTRIBUTORS

KATE MOTHES is founder and curator of Young Space and Co-founder/Editor of Dovetail Magazine. Mothes earned a Bachelors in Art History from the University of Wisconsin - Madison, and a Masters in the History of Art, Theory and Display from Edinburgh College of Art at the University of Edinburgh. Her projects and research are concerned with the intersection of curating, publishing, and artist-run culture in global contemporary art. She is currently based in Wisconsin.

ANTHONY LOVENHEIM IRWIN is Postdoctoral Fellow in the Society for the Humanities at Cornell University. He thinks, talks, teaches, and writes about the social and ethical resonance of crafting, building, and construction. Dealing primarily with Buddhism in Thailand, his work focuses on the importance of craftspeople as central figures in the transmission and definition of religious traditions and communities. His research has received funding from the American Council of Learned Societies, The US Fulbright Program, and the Australian National Research Council.

WENDY WEIL ATWELL is a writer living in San Antonio, Texas. She received her MA in Art History and Criticism from the University of Texas at San Antonio in 2002. She writes literary nonfiction and reviews of art for various visual arts publications, both online and in print, including Gulf Stream Magazine, Art Lies, GlassTire, Rivard Report and ...might be good. Atwell is the author of The River Spectacular, published in 2010.

THE PAPER ARTIST COLLECTIVE is a global community of artists with a shared passion for creating beautiful things from paper run by paper artists Kristine Braanen and Samantha Quinn. paperartistcollective.com

LIZ MILLER is an artist who explores the fallibility of infrastructure and the precariousness of perception, as seen through a materially-intensive, process-based lens. Miller hosts a series of artist interviews on her website: lizmiller.com. She is Professor of Installation and Drawing at Minnesota State University-Mankato and lives and works in Good Thunder, MN.

A WORKING ARTIST FOR 20 YEARS,

Michael Velliquette has participated in over 150 exhibitions in museums and galleries in the US, Europe and Asia. His work is in the permanent collections of the Chazen Museum of Art; the Art Museum of South Texas; the Racine Art Museum; The San Antonio Museum of Art; The Progressive Corporation; The John Michael Kohler Art Center; and The Microsoft Collection.

He has participated in several residencies and cultural exchange programs including the Artpace International Artist-in-Residence; the SÍM Residency, Reykjavik; the John Michael Kohler Art/Industry program; and EUARCA, Kassel, Germany. In 2021 he will be artist resident at the Houston Center for Contemporary Craft.

His work has been featured in numerous print and online publications including Colossal, Time Out New York and The New York Times. He has been included in several compendiums on paper art produced by such publishers as Thames & Hudson, Gestalten, Sandu, Lark Crafts, Hightone Books.

He is represented by the David Shelton Gallery in Houston, TX.

As an arts educator Velliquette is on faculty at the University of Wisconsin-Madison where he teaches courses in visual literacy and creative practice. He also teaches workshops on both his work and the paper arts, and in 2019 taught a course called "Sculptural Paper Craft: Form and Freedom" at the Haystack Mountain School of Craft.

He is member of the Guild of American Papercutters and the Paper Artist Collective—a global community of artists and designers dedicated to the medium of paper.

He lives in Madison, WI with his husband Tehshik Yoon, an organic chemist.

www.velliquette.com

INDEX OF ARTWORKS

14 & 15 *When Awareness Encounters Eternity It Creates Time*
Paper sculpture
12" x 12" x 6"
2018

16 & 17 *When Awareness Encounters Infinity It Creates Space*
Paper sculpture
12" x 12" x 6"
2018
Private Collection, San Antonio, TX

18 & 19 *My Looking Ripens Things and They Come Toward Me, to Meet and Be Met*
Paper sculpture
12" x 12" x 6"
2019

23, 24, & 25 *Let Your Hand Rest on the Rim of Heaven*
Paper sculpture
20" x 20" x 6"
2019
Rick Liberto Collection, San Antonio, TX

26 & 27 *All Seeming Things Shine With the Light of Pure Knowledge*
Paper sculpture
18" x 8" x 8"
2019

28 & 29 *The Love That Would Soak Down Into the Center of Being*
Paper sculpture
20" x 20 x 8"
2020

30 & 31 *Our Newly Awakened Powers Cry Out for Unlimited Fulfillment*
Paper sculpture
30" x 8" x 8"
2020

+++ Artwork photos by Jim Escalante
Studio documentation and bio photos courtesy the artist

CPSIA information can be obtained
at www.ICGtesting.com
Printed in the USA
LVHW070554201120
672145LV00004B/70